ROOFTOP

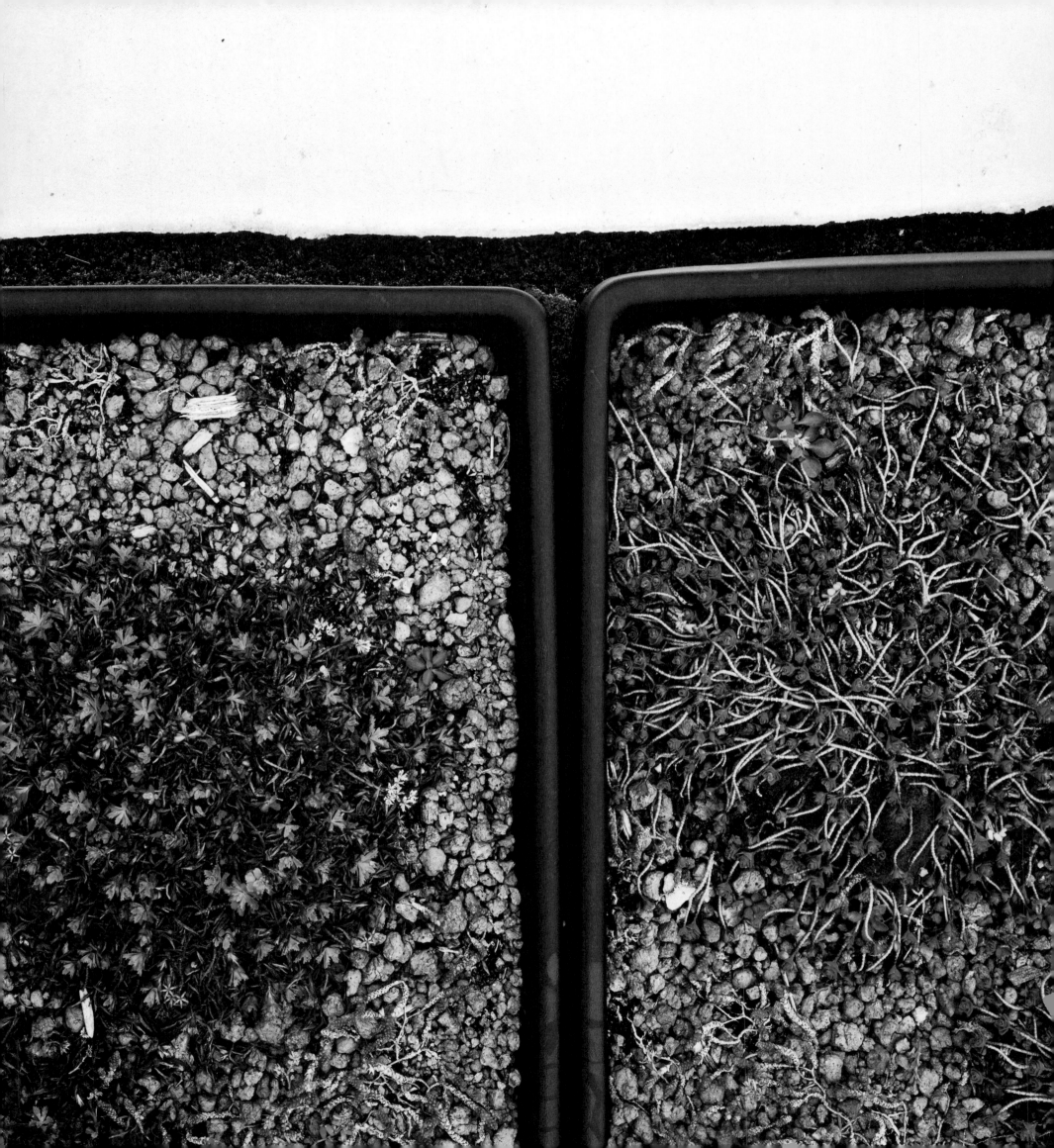

ROOFTOP

BRAD TEMKIN

with essays by

STEVEN W. PECK

ROGER SCHICKEDANTZ

JOHN ROHRBACH

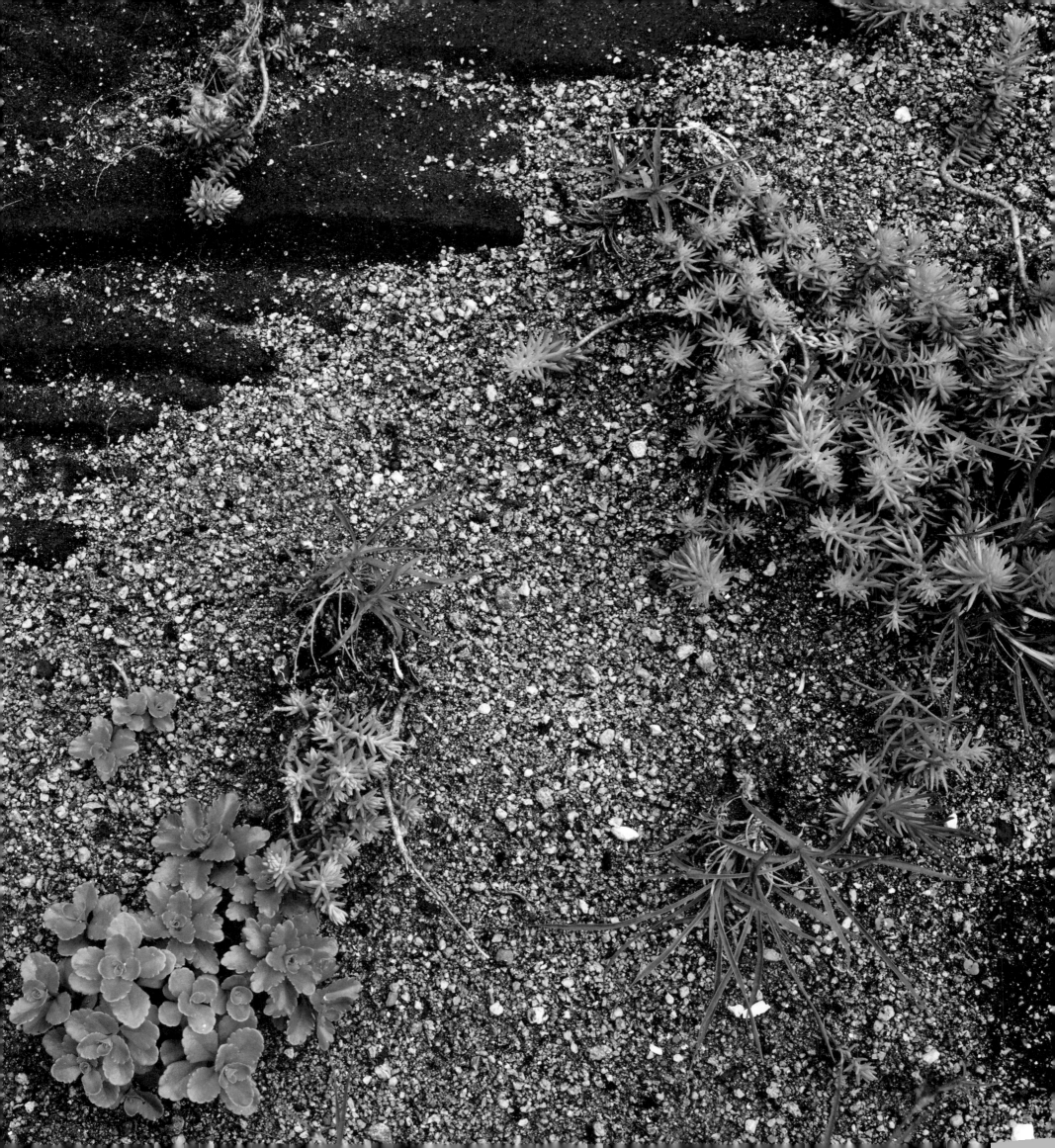

PREFACE

Steven W. Peck

WESTERN CIVILIZATION is built largely on the concept that humans are separate from, rather than part of, Nature. Yet we are finding not only that is this not realistic, but that this idea contributes to some of the enormous challenges we now face.

Over centuries we have built great cities filled with fantastic promenades, roads, bridges, and both mundane and awe-inspiring buildings. Now, for the first time in human history, more than half of humanity lives in cities and many people spend most of their time indoors. When not inside buildings, many of us crowd onto busy freeways or into packed trains on our daily commutes. Millions more, particularly young people, currently spend most of their waking time living in the virtual, electronic world, a place devoid of nature. As a result, we are increasingly divorced from an experience with nature and the life-giving services that ultimately sustain us. An entire generation is growing up knowing more about the geography in a video game than the place in which they live. They will never experience the joy of climbing an apple tree, watching as bees float between flowers collecting nectar, or seeing how an orb spider delicately places each strand of silk to make her web. But with our growing alienation from nature, there is much more at stake than pleasant childhood memories.

The idea that humans have an innate love of life and living systems is called the biophilia hypothesis. It was first articulated and popularized by E.O. Wilson, an eminent biologist, in his 1984 work *Biophilia*. Our fundamental affinity, or philia, for nature is the flip side of our shared fear, or phobia, of things like snakes and spiders, which can harm us. Wilson argues that biophilia is deeply rooted in our evolution; we are hardwired to want to have an experience of nature. In other words, this experience of makes us fully human.

While cultural representations of nature vary, biophilia appears to exist in all humans regardless of their language, race, nationality, or culture. Our positive physical and mental reactions to things such as swaying grass, walking through a forest, or waves crashing on the beach are universal. In his seminal book *Last Child in the Woods* (2005), Richard Louv put forward the idea of "nature-deficit disorder." Nature-deficit disorder refers to the problem of not spending enough time in nature, which leads to many behavioral problems in children and unhealthy mental and physical development into adulthood. A growing body of scientific research demonstrates that we require an experience with nature in order to be mentally and physically healthy. An exhaustive review of the literature led by Dr. Kathleen Wolf, University of Washington, has uncovered more than 1,000 peer-reviewed scientific

studies over the past 30 years that correlate access to green spaces with positive health outcomes at all stages in human life, from embryonic to senescence.

Wilson's biophilia hypothesis has given rise to another revolutionary idea: biophilic design, which is championed by Stephen Kellert, Martin Mador, and Judith Heerwagen, to name a few. In *Biophilic Design* (2008) they propose two dimensions of biophilic design. The first is an organic or naturalistic dimension, defined as "shapes and forms in the built environment that directly, indirectly, or symbolically reflect humanity's inherent affinity for nature. Direct experiences include our contact with the natural environment through features such as daylight, plants, natural habitats, and ecosystems. Indirect experiences involve contact with natural features that require ongoing human input, such as potted plants or water fountains.

The second dimension of biophilic design is place-based or vernacular, defined as buildings or landscapes that connect the culture and ecology of a geographic area. This is said to be like "the spirit of the place." One achieves this by combining natural and human-made elements and, as a result, ensures that future generations will prevent it from being destroyed. Human natural affinity for a place causes people to protect it. Kellert and his colleagues further developed the paradigm of biophilic design, breaking it down into six major design elements comprised of 70 specific design attributes. Within this typology, one of the design elements, "environmental features," involves the use of attributes such as sunlight and water, views and vistas, natural materials and façade greening. Realizing the benefits of biophilic design, then, requires that designers incorporate these and other attributes into their building projects. Integrating nature into the built form through the use of living green infrastructure such as green roofs, green walls, bioswales, and urban forests can result in much healthier and happier people.

This coming paradigm, a shift towards biophilic design, has received additional support when its presence, or absence, is economically valued and understood as having a direct impact on the bottom line. One of the more comprehensive works in this regard is by Bill Browning, Terrapin Bright Green, called *The Economics of Biophilia: Why Designing with Nature in Mind Makes Financial Sense*. Browning and his collaborators review the scientific literature as it pertains to employee absenteeism, employee presenteeism, hospital recovery rates, retail sales, and children's test scores and calculate the costs and benefits of each. This helps present a strong financial case for adopting biophilic design practices. Simple steps such as day lighting offices and offering quality views, they estimate, can save approximately $2,000 in lost productivity per employee each year.

The integration of living green roof systems with nonliving building elements is well captured within this book by photographer Brad Temkin. These images demonstrate that a new design practice is taking root, one with multiple biophilic attributes—that of living architecture.

Living architecture represents a fusion of landscape architecture, architecture, and engineering. Its practice involves the integration of living, organic systems with nonliving, inorganic systems within or upon a building. Living architecture has an immediate and profound effect, experienced by anyone who comes in contact, for instance, with one of Patrick Blanc's large green walls or by anyone who has stepped off New York's busy streets onto the High Line. These types of spaces blur the sharp distinctions between buildings and nature.

The widespread adoption of living architecture holds the promise of satisfying many of our biophilic needs in busy and crowded cities. In a very practical sense, living architecture also provides previously unimagined opportunities to reduce the heat of our cities, minimize greenhouse gases, manage and better use storm water, and even grow food and build community on roofs that were once lifeless and barren. Green roofs have also been proven to reduce energy consumption, improve solar panel efficiency, extend water-proofing life expectancy, and contribute directly to people's health and well being. Living architecture can be designed to clean the air, support urban biodiversity including birds, endangered plants, and insects, and add an ever-changing seasonal element of beauty to buildings.

Our world is changing rapidly, perhaps more quickly than at any other point in our history. How we conceive of our place in the world needs to change in response. If we continue to increase our separation from nature by using traditional city-building practices and by escaping into the virtual world of computer programs, we will continue to lose touch with that which ultimately sustains us, and we will have little interest or political will to make the changes to ensure a more promising, sustainable future. If we continue to become more alienated from nature with our video games, automobiles, buildings, and cities, this will contribute to our ultimate undoing.

The many amazing projects presented throughout this book allow us the opportunity to pause and reflect upon how we may embark on a much different path; a path that incorporates living architecture and thereby allows us to reconnect with nature every day where we work, live, or play, and perhaps even rediscover the wonder of ourselves within her.

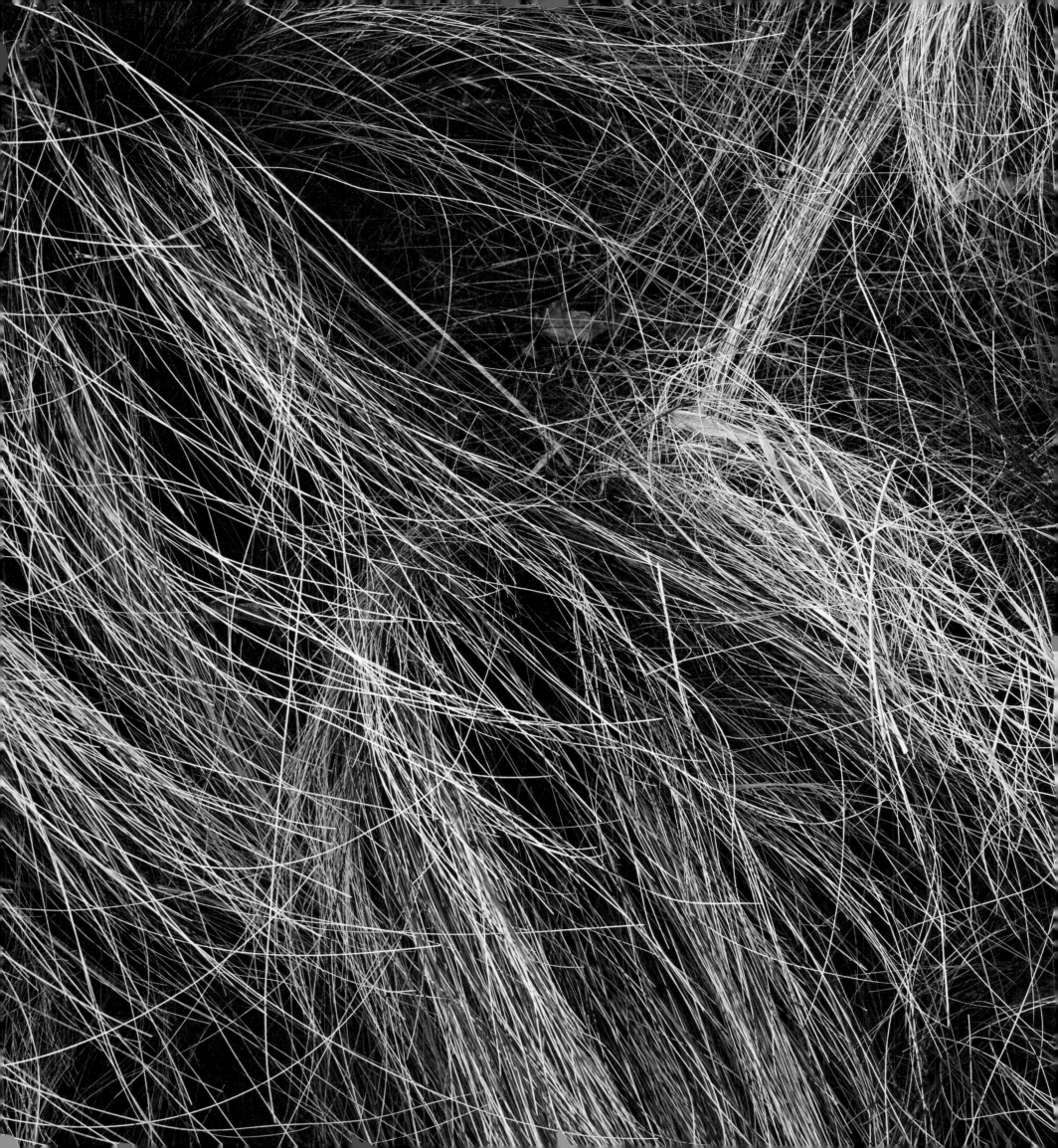

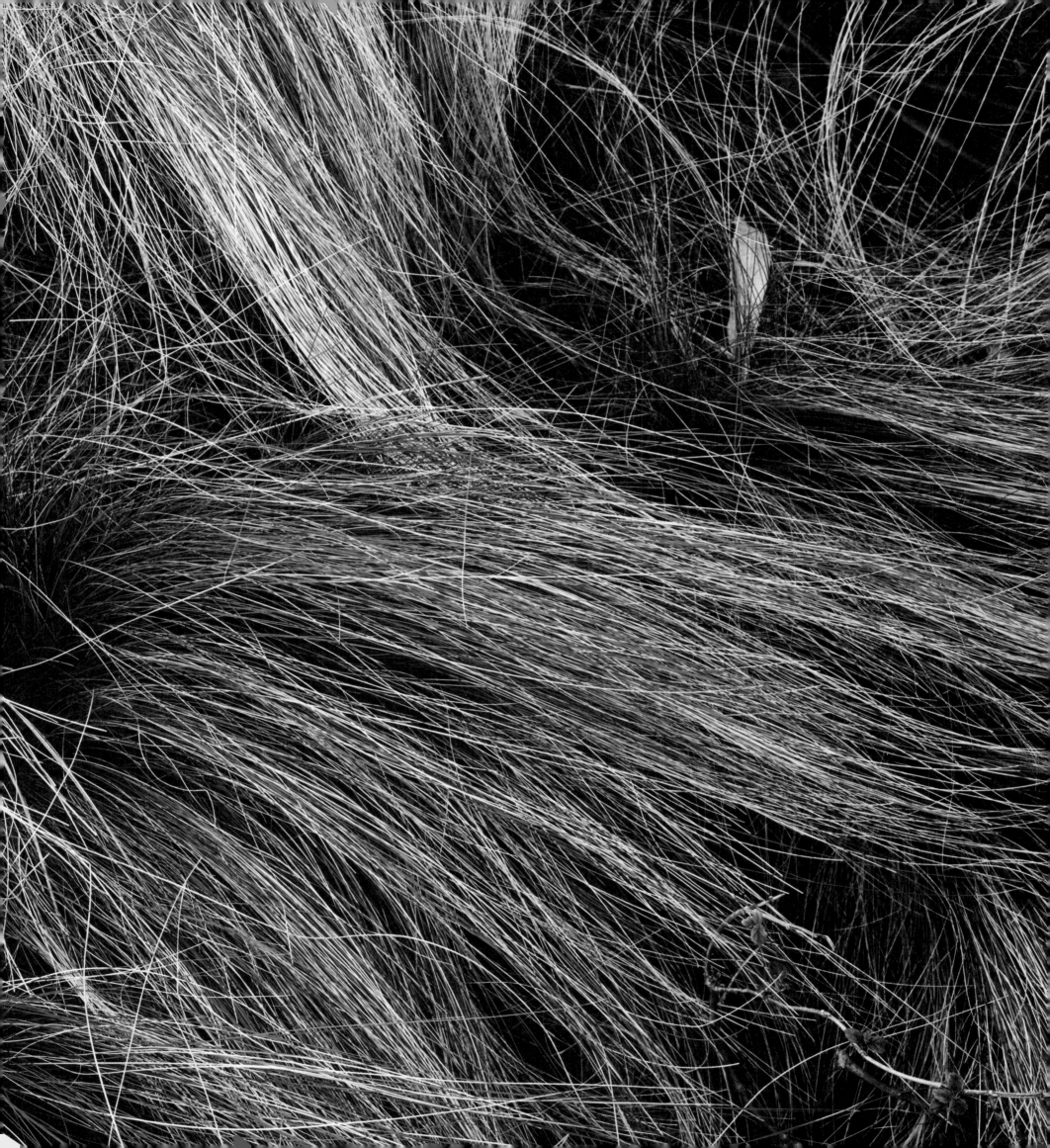

INTRODUCTION

Roger Schickedantz

BRAD TEMKIN focuses on a relatively new presence in the American landscape: the naturalized roof. The large-scale planting of vegetation on roofs is a little recognized advance of our time made possible by recent innovations in construction technology. It reflects the confluence of two trends: popular concern for the environment and a psychological need for reconnection to the natural world.

Temkin's photographs of these seldom-seen tableau in the sky conjure a certain dystopian unease. They recall images of weeds growing through cracked asphalt, an invocation of future ruin that speaks to a day when humans have vacated the planet and left it for nature to endure. This is merely by suggestion, however. In far greater measure the photos convey an underlying orderliness and ordinariness, a comforting imposition of will, a carefully engineered human intervention driven by an impulse to harness nature to human ends.

Temkin captures a significant shift in architectural expression. This architecture is a new artistic medium in which nature and humanity contribute equally. It represents a departure from the traditions of the past in which buildings were conceived in opposition to nature.

AN AESTHETIC APPRECIATION OF NATURE

To see how this reinterpretation of architecture's role has come about, it is useful to understand today's green roof phenomenon within the context of Western artistic and scientific pursuit.

In his 1993 play *Arcadia*, Tom Stoppard introduced a theme of landscape gardening as a stand-in for the dialectic between Classical and Romantic philosophy: thinking versus feeling. He juxtaposed the new romantic landscapes then being installed in 1820s Britain with the classical formal gardens they were replacing, capturing a time of transition in which Lancelot "Capability" Brown and other landscape architects were reimagining the English estates. In place of classic French geometries and axes, there was an emphasis on naturalistic realism with a gothic bent. It was not true nature, but an artful distribution of natural-looking features, a picturesque composition meant to appear as if naturally occurring. Derived from contemporary landscape painting, these manufactured scenes often included small folly buildings, invoking an idealized world in which the artist, both painter and gardener, played at being God. It was a rethinking of the place of humans in nature. Nature was there to be tamed for human pleasure.

This sanitized picture of nature, as benign and gentle, is nature as we wish to imagine it rather than the cold,

harsh, uncivilized force that actually exists. It is illusion and artifice.

In this passage, Lady Croom, the mistress of the house, comments to her landscape architect Mr. Noakes on his design drawings for the renovated gardens:

LADY CROOM: … −look! Here is the Park as it appears to us now, and here as it might be when Mr. Noakes has done with it. Where there is the familiar pastoral refinement of an Englishman's garden, here is an eruption of gloomy forest and towering crag, of ruins where there was never a house, of water dashing against rocks where there was neither spring nor a stone I could not throw the length of a cricket pitch.

BRICE: It is all irregular, Mr. Noakes.

NOAKES: It is, sir. Irregularity is one of the chiefest principles of the picturesque style −

LADY CROOM: but Sidley Park is already a picture, and a most amiable picture too. The slopes are green and gentle. The trees are companionably grouped at intervals that show them to advantage. The rill is a serpentine ribbon unwound from the lake peaceably contained by meadows on which the right amount of sheep are tastefully arranged—in short, it is nature as god intended, and I can say with the painter, "Et in Arcadia ego." Here I am in Arcadia…

Strikingly, the impetus behind this conversation is not the re-creation of nature, but the creation of a picture of nature as it had been interpreted by others in the past. The essence of the question they debate is not, what is the truest expression of nature? Rather it is, which historical style is appropriate to our cultural ends? Ultimately Stoppard's play does not come down on the side of thinking versus feeling, or a particular architectural style for that matter, but argues for a balance of different perspectives: a realization that a rich life comes through an unpredictable interplay of factors and forces.

In the world of contemporary building design, there has been a similar acceptance of difference. The expectation of a singular style for our time has become more accommodating of individual expression. Whether for better or worse, this democratization of style is in sync with a contemporary culture that celebrates multiplicity. There is no longer a battle of styles. If anything, debate is absent. In place of style there are now philosophies that influence architectural creation either from the top down or from the bottom up.

The top-down approach imposes an idealized aesthetic vision occasionally divorced from practical considerations of manufacture, installation, and maintenance. It is primarily concerned with expressions of the human spirit. Leading-edge practitioners of this kind of form-making champion an architecture of indeterminate shapes. At the most extreme, computer-generated designs derived from fractal geometry echo organic forms found in nature. Current design of this sort often expresses fluidity and speed.

In contrast, the bottom-up, technological approach has arisen out of building craft. It is an historical evolution of problem solving with origins in indigenous cultures of the past. For example, sloped roofs and extended eaves were originally developed to direct rain away from a building's perimeter. This tradition has endured over centuries as a practical solution to issues of longevity and endurance. A primary impetus over many centuries has been to keep out rain, intense sunlight, and extremes of heat and cold, while encouraging refreshment of air through ventilation. Building materials that can survive over long periods have an advantage over ones, such as wood, that must be replaced or protected with coatings.

Technological progress has long been defined in opposition to nature. Whether through advances in artificial lighting, refrigeration, or vertical building transportation, the drive was to overcome nature's limitations; to triumph over it rather than work in partnership with it. The architectures of concrete, steel, and glass established an aesthetic around the apartness of humans and nature. New materials and products emerged from traditional ones, altering the appearance of buildings as a result.

One place that the contemporary aesthetic and technological approaches have begun to converge is in the incorporation of elements of living nature in buildings. Whether on roofs or on walls, inside or outside, there is a growing appreciation that nature is integral to our well-being. As in *Arcadia* though, it is a picture of nature manufactured to support a contemporary aesthetic. Nearly 100 years on from the reinvention of the English garden, nature is making its way into and on top of buildings in a new and unprecedented way.

NATURE AND BUILDINGS COMING TOGETHER

A whole study has arisen on the topic of biophilia, the human subconscious need to be connected with nature. More than merely a love of nature, biophilia examines the symbiotic relationship between humans and nature, and the deep psychological preference we have for elements of the natural world An innate appreciation for symmetry, geometry, and mathematical series can be tied to forms

found in nature. Research has shown that people are more alert when exposed to views of daylight and clouds in schools and workplaces. Hospital patients with views and access to gardens recuperate at much faster rates. Altogether, as much as we may pretend otherwise, we humans are a subset of this Earth. As a species we are becoming ever more aware of our place on it and the need for stewardship of it.

The contemporary green roof phenomenon in buildings is a convergence of the building and gardening instincts. It is one that celebrates the use of vegetation on buildings as an expression of a living organism as well as merging the human and natural landscapes. This shift in attitude has resulted in an overturning of conventional expectations of buildings, from rational, hard-edged structures to something that is softer and tied more closely with wild nature. Not exactly a shift from thinking to feeling as Stoppard suggests, but a change in how we perceive our place in the world nevertheless.

Our attempt to re-create nature in our buildings is not a replication but a simulation. While using real plants and soil, rather than plastic, and resulting in some real benefits to air quality and psychological comfort, we are not re-creating true nature. As in Lady Croom's world, it is still an artifice constructed of natural components. When nature is confined to a building—whether a roof or balcony—its ability to replicate is limited. It may support particular insect and bird habitats, but not necessarily the habitat that would exist on the ground with native plant species. This is not wild nature. If plants die, they can be easily replaced. This remains a controlled human environment. The green roof is merely the new garden arbor, the folly, and the trellis, expanded to encompass the whole building.

A HISTORY OF GREEN ROOFS

There are examples of green roofs throughout architectural history, whether of vernacular Scandinavian sod roofs, thatched roofs on farmhouses in England, or sod prairie houses in the United States of the early 1900s. Thick sod keeps the heat inside in cold climates and outside in hot ones. Unfortunately it is heavy, not waterproof, difficult to secure to the outside of a dwelling, and susceptible to washing away. Sometimes these roofs came about accidentally, such as happens when weeds take root in thatch. For the most part, however, vegetation on roofs was considered to be disruptive. Nature changes over time: trees grow, roots dig deeper for water, and leaf matter decomposes into soil. These processes run counter to the stability and longevity we strive to create in our structures.

Western modernism, as expressed through the Bauhaus movement, was a rejection of everything that came before. It championed the expression of products of the Industrial Revolution, and banned ornament. With the exception of an occasional ivy-covered wall, any thought of including vegetation seems to have been anathema. Like the English Gardens, the abstract forms of modernism were inspired by visual artists, in this case the cubists and forerunners of abstraction. The abstract was glorified and did not leave a place for nature. It was an architecture of pure form. If a stray plant took root on one of the ubiquitous flat roofs, it was unintentional.

The development of modern green roof technology arose out of necessity rather than style: the need for aircraft hangar camouflage during World War II and the Cold War. Countries such as the United Kingdom and Germany built concrete bunkers to house airplanes and buried them under sod. Sod must be deep in order to retain water, however, and vegetation tends to turn brown or die without sufficient water. Technology was developed in Germany to create lightweight coverings that would support healthy plant growth. Sedum plants, succulents having the ability to maintain a green color in hot summer months, were cultivated for this purpose. The resulting research and development was the source of a new industry in Germany that has since become the standard for green roof technology worldwide. In the 1980s and early '90s green roofs became common in many German cities. In Stuttgart, for example, they became required as a means of controlling storm water runoff. This was a novel solution for absorbing surges of surface water in order to prevent expensive expansion of underground storm sewers. Finally in the mid 1990s these strategies began to spread to North America as part of a burgeoning green building movement.

A CULTURAL SHIFT

In the countercultural atmosphere of the 1960s and '70s—echoed in today's back-to-the-earth movement— people started thinking about earth connectedness. Perhaps it was a reaction to space flight and the fear of losing control of our Earth, the defining parameter of our existence. A growing awareness of the environment resulted in the Clean Air and Water Acts, and spawned initial attempts in recycling. Abetted by proselytizers such as Stewart Brand and his Whole Earth catalogue, a desire for self-sufficiency became manifest, fostering a utopian ideal to live off of the land. There was a fascination with caves and earth-sheltered houses. In Europe, old traditions of thatch and soil roofs were being rediscovered.

For the most part, however, the thought of combining vegetation and buildings had not occurred to the architectural profession. In Paul Heyer's influential 1966 book, *Architects on Architecture*, a summary of important U.S. architects and their buildings and a bible for architecture students into the 1980s, the only example approaching, or that could even be considered a predecessor to today's green roof, is the 1969 Oakland Museum by Kevin Roche John Dinkeloo & Associates. A building that integrated building and landscape, constructed of terraces covered with roof gardens, it was an unusual example for its time. Unlike today's shallow green roofs, however, deep soil was required for planter boxes lining the roof edges. It is really conceived as a street-level park, which happens to have a building buried underneath it.

Perhaps Joni Mitchell's words of 1970, "they paved paradise to put up a parking lot," provided a significant challenge to a new generation of architects. "They took all the trees, and put 'em in a tree museum / And charged the people a dollar and a half just to see 'em." What better way than through popular culture to inspire new dreams? Whether influential or not, beginning in the 1980s a few architects began visioning buildings which were integrated with nature. The early efforts were fairly tame in terms of numbers of constructed buildings. More often it was the visionary drawings, displayed in books and museums, which made an impact on students and future practitioners.

Emilio Ambasz was one of the first to visualize a radical architecture in which buildings were embedded in and grew out of the Earth. The forms were abstract and sculptural, in the modern tradition, but were carved out of the landscape rather than sitting in opposition to it. As his work developed, trees were incorporated within open three-dimensional frames at multiple levels. A 1989 exhibit at the Museum of Modern Art gave his ideas wide exposure. Finally in 1994 Ambasz's ACROS building in Fukuoka, Japan, was completed. The predominant design idea was of tree-covered terraces creating a stepped artificial hillside. "My way of doing ornament is by using nature," he has stated.

Other architects such as James Wines at SITE and Steve Badanes at Jersey Devil (1979 Hill House, San Francisco, CA) envisioned buildings completely covered in vegetation. This was something entirely new in the modern movement: buildings that disappeared into the landscape. For the first time, nature and architecture were being integrated to create a wholly new aesthetic, and one that could only be implemented by applying new techniques to known building construction practices.

ADVANCEMENT OF BUILDING SCIENCE

Just like other technical innovations of the 20th century, the success of green roofs is owed, in no small part, to the development of a whole series of subtechnologies that, when combined, form a new whole. These include sheet roofing membranes with welded seams that provide a complete and reliable waterproof barrier, rigid polystyrene insulation that can resist weight and perform when wet, filter fabrics that prevent the growth of damaging roots in the waterproofing layer, and various devices for retaining water beneath the surface to provide irrigation. More recently, technologies for subsurface leak detection have allayed the fears of building owners and led to wide-stream acceptance.

It is the technological innovation allowing lightweight green roofs that has allowed them to flourish, combined with a moment in time when architects are concerned about energy and water efficiency, global warming, and environmental degradation. With a single design strategy, green roofs address a multitude of environmental issues. Much of the rationale for green roofs comes out of the building science tradition. They are promoted for increasing building insulation, capturing rainfall, and increasing roof lifespan. Less frequently stated, but of equal importance, green roofs provide habitat for diverse plant, insect, and bird species, helping to compensate for acres lost to asphalt roofs and parking lots. Much has been made recently of the plight of the Monarch butterfly. The yearly migration from Mexico through the Great Plains has been decimated by loss of Milkweed due to an increase in bioengineered crops and subsequent reduction of beneficial weeds. With the appropriate vegetation, there is an opportunity for green roofs to replace these migration corridors.

THE NEW FRONTIER OF ROOFTOP FARMING

Since the recession of 2008 there has been a strong back-to-the-land movement, reinvigorating a primal urge to dig in the soil, plant our own gardens, and grow our own food. Localized farming has been a great success, resulting in farmers' markets springing up equally in large cities and small towns. Food is more nutritious when eaten near the time of harvest. Specialized foods suddenly become feasible because they can be sold locally and don't require long-distance shipping. Further, less reliance on pesticides is required for small-scale farming. At a national scale, energy use for transportation is reduced, a benefit for carbon reduction and thus for countering global warming.

At a grassroots level this groundswell of sentiment is a response to many economic challenges. Chief among them

is the opportunity to earn income self-sufficiently while keeping money in the community. As a side benefit, people feel more in control of their lives and less dependent upon big corporations. Food regains meaning as part of a cycle of birth, growth, and death. Local produce is something real in a world that is more and more mass-produced.

The popular interest in food production has expanded to entrepreneurs who are starting cottage industries growing food on rooftops in dense cities where open land is scarce. While originating with people searching for a different food production model, these efforts are still small scale and experimental. If they are to have a meaningful impact on agriculture, they will necessarily expand to a more industrial agricultural scale. In the world of sustainable architecture, this is the next frontier. Growing our own food on our own roofs is a way to re-establish the predominance of the local over the global.

CONCLUSION

Whether through the human expression of growing our own food, or simply by being more completely enveloped in a naturalized environment, the embracing of nature becomes an antidote to our hi-tech world. We want to feel soil running through our fingers, to become more connected to our earthly origins. Perhaps we are retracing the steps of the English in the 1800s as they responded to the pollution and landscape desecration brought about by the Industrial Revolution.

Much of the impetus for this new focus on revegetating the built environment, therefore, is restorative. It is about trying to regain a lost Eden, starting over again in an attempt to achieve purity, erasing the ravages of the industrial past, returning to an imagined "primitive" time—even though, ironically, achieved through advances in technology.

In the 20th century we understood more completely that our world is governed by the unknown. As manifest in quantum mechanics, particle/wave motion, and the Heisenberg Uncertainty Principle, the role of humanity seems increasingly unpredictable and inconsequential. In the 21st century the possibility of limits to Earth's stability has become a defining concern. Science fiction in popular culture has capitalized on fears as old as Pompeii and Herculaneum. As captured in the 2014 film *Interstellar,* the Earth has become uninhabitable and human survival depends on colonizing distant planets. Periodically, humanity seems to take a keen interest in the possibility of our own destruction.

So are we driven primarily by a fear of global catastrophe? Is our drive to protect the Earth's environment a countermeasure against the emptiness of the universe, a bold proclamation that we will hang on? Or are we caught up in a naïve hope for destruction, rebirth, and renewal, a chance at a new Eden?

Temkin's images capture this emerging worldview in which humans and plants are engaged in a mutually beneficial relationship. We are in this together. Our lives are improved physically and psychologically when we work with nature. Consequentially, Temkin's photographs also mark a reinterpretation of traditional architectural photography. Rather than celebrating the building as an object in the landscape, these photographs celebrate the disappearance of the building *into* the landscape.

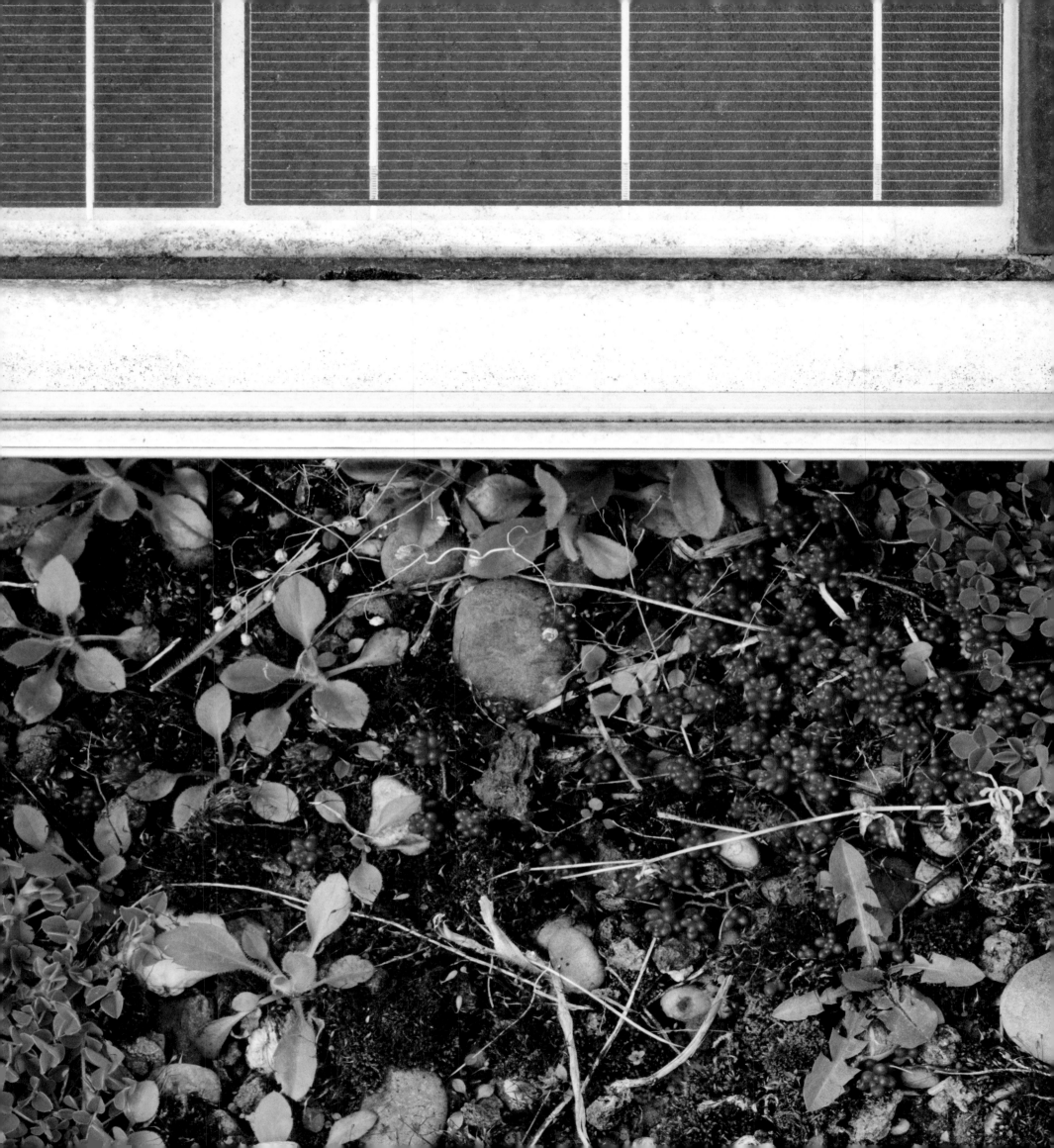

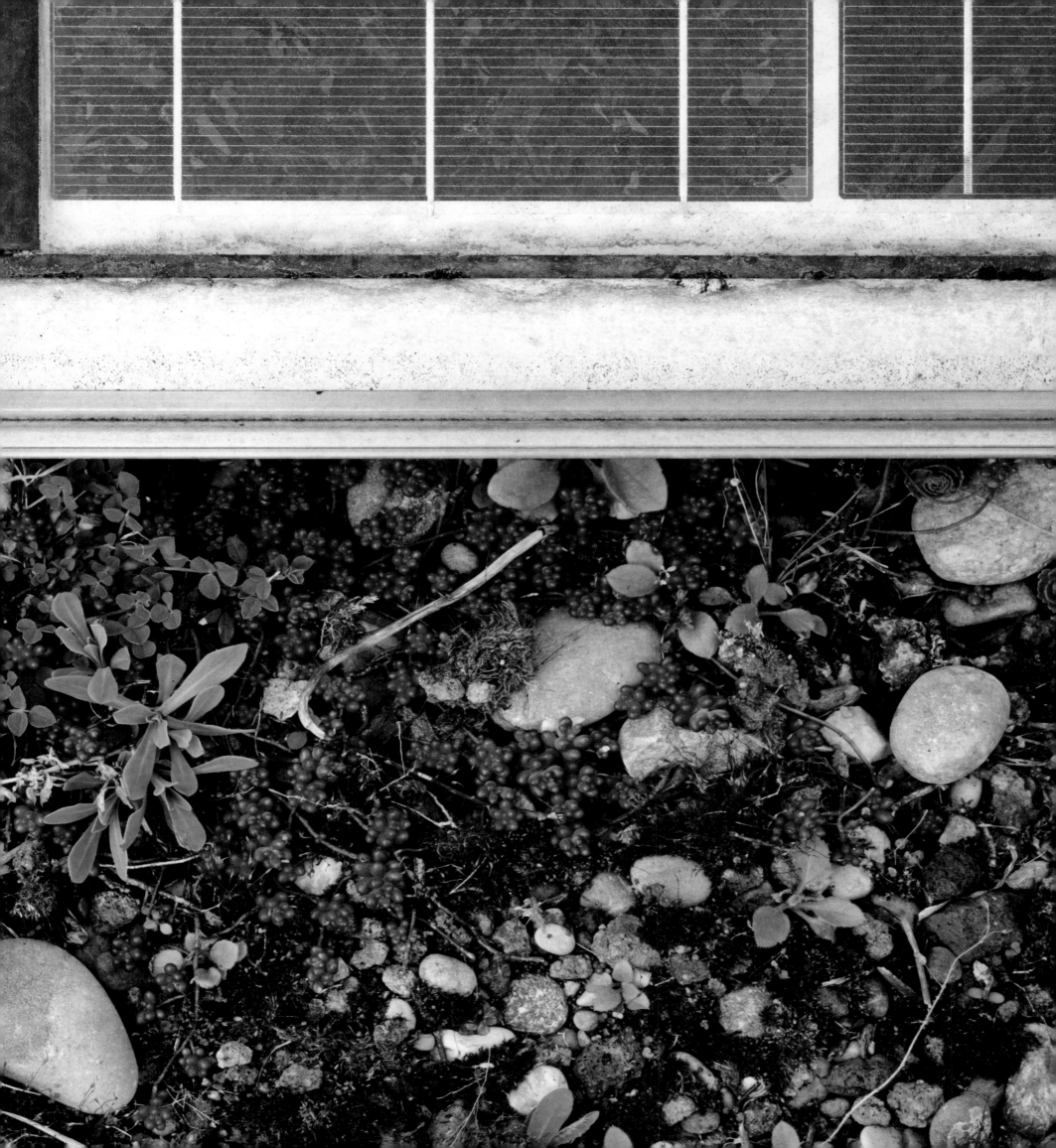

SEEING GREEN

John Rohrbach

THIS BOOK IS AN OUTGROWTH of an expansive national initiative begun on April 22, 1970. Organized by the bipartisan team of Democratic Senator Gaylord Nelson and Republican Congressman Pete McCloskey, Earth Day saw twenty million Americans from across the political spectrum gather at thousands of rallies in towns large and small around the nation not merely to protest pollution and the ongoing destruction of natural resources, but to call for the embrace of a more community-oriented and sustainable approach to living. When three years later the Organization of the Petroleum Exporting Countries (OPEC) started withholding oil shipments to the United States and other Western nations in response to American military support for Israel during the Yom Kippur War, the resulting scarcity of petroleum products and related jump in prices forced people across the developed world to put the promises they made on that first Earth Day to work by rethinking how they drove and set the thermostat in their homes and businesses. The predicament gave important impetus to ongoing German technical research into the ancient technology of green roofs.[1] Problems of weight, drainage, and waterproofing were quickly overcome, and the modern green roof movement took hold as a means to improve building insulation, control urban water runoff, and cut human-generated pollution.[2]

In 2009 Brad Temkin decided to turn his camera on the green roof movement by photographing the largely corporate applications of its technology. It could be argued that green roofs are mere Band-Aids in a world already coping with fast-rising temperatures, but installing them is better and more responsible than doing nothing. Temkin's artful photographs highlight the variety and beauty of these horticultural building tops, drawing attention to their contrast with their urban surroundings. They remind us of the green roof movement's solid foothold in Europe, though they mostly point out the growing embrace of such roofs across America, and Chicago's leadership in particular. Temkin's Chicago hometown now has more green roofs than any other American metropolis. In 2010 alone it added 600,000 square feet of plant-covered roofs in support of its goal of having 20% of its buildings covered by such roofs by 2020.[3] Yet rather than catalogue the block-to-block expansion of these roofs, Temkin's goal is to offer more general support for the movement by highlighting the counterpoint beauty of these roofs against their urban backdrop. They frame advocacy within the poetic, heralding the beautiful, living multiplicity of plant life filling these roofs that are so incongruously, increasingly scattered against our urban skylines.

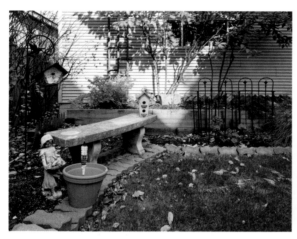

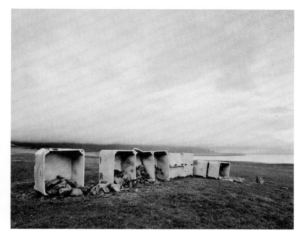

Fig. 1: *Private Places, Bench, Lakeview,* 2004

Fig. 2: *Relics X,* 2007

This project is more overtly political than Temkin's previous photographic initiatives, but it reflects his same long-standing fascination with the marks that humanity leaves on the land. In the early 2000s he focused his camera on the compact gardens he encountered while walking the streets of Lakeview, Pilsen, Wicker Park, and other neighborhoods situated just beyond Chicago's downtown. Reveling in the appealing individuality of these settings, he attended not to their plant life as much as to the tables, chairs, toys, and the abundance of decorative objects filling them, like birdhouses, barber poles, and accoutrements dragged back from an antique shop or family farm (Fig. 1).[4] The images make clear the continuing allure of, and even need for, nature in urban settings. Even if Temkin calls the series *Private Places*, the images really celebrate how these gardens extend indoor rooms into the public arena. They openly accept that strangers can look in, even if only from the windows of surrounding buildings. They also are spaces where the vagaries of weather and the changing seasons are accepted and even embraced.

Around 2004 Temkin shifted his sights to the dramatic, glacially scraped, coastal landscape of northern Europe and Iceland. But rather than follow tradition and celebrate the open, barren expanse of these rocky, grass-covered terrains, he focused his camera on the residue of human activity—iron frameworks sitting empty in a field, a twisted steel guardrail snaking into the distance, randomly scattered oversized wood cores, and oddly shaped concrete posts and towers—all sitting desolate and seemingly ignored, as if forgotten (Fig. 2). Each item was clearly built for a

specific purpose, but Temkin leaves it up to us to decipher that intended use. Their age and isolation, and the lack of current activity around them, transform them into strange, marvelous sculptures. Having lost their context, they become "relics" of some undefined, lost age.

Temkin's photographs of green roofs combine the diversity and allure of nature found in his garden series with the expansive isolation inscribing his *Relics* series. Equally utilitarian and picturesque, green roof gardens are manifestly elitist, yet framed by populist good will. They rarely are accessible, save by landscape crews and maintenance workers, nor are they meant to be. They sit quietly above street level offering their changing beauty to bankers, financiers, and executives—another perk of wealth and status—and even to them only at a distance. Since they cannot be seen from the street, most people have no idea that they even exist save through the self-congratulatory press releases put out by their corporate owners. Temkin thus practices a ruse. He clearly gained special permission to photograph them, to delight us with their color and variety. But however much we would like to find oasis within their bounds, they remain inaccessible and strangely devoid of human touch, save for the fact of their creation (pg. 72).

In 1920 photographers Charles Sheeler and Paul Strand drew attention to the psychological shrinkage of humanity brought by the rising skyscraper city in their avant-garde short film, *Manhatta*. The photographs filling this book do the same, asking viewers to account for their own miniscule, semi-irrelevant position in the urban social fabric (pg. 44).

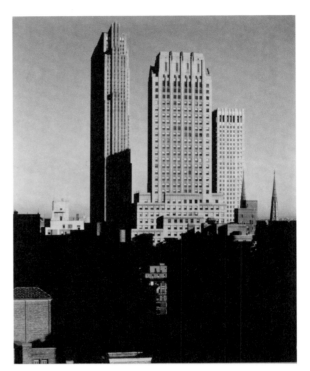

Fig. 3: *From the Shelton, West.* 1935. Gelatin silver print (chloride), 9⁷/₁₆ x 7⁹/₁₆ inches (24 x 19.2 cm). Gift of Miss Georgia O'Keeffe. The Alfred Stieglitz Collection. Image © The Museum of Modern Art/ Licensed by SCALA/Art Resource, NY

But these images stand more aligned with Alfred Stieglitz's 1915 quieter views out the back window of his tiny Fifth Avenue gallery, and his early 1930s photographs out the windows of his midtown abode than the dizzying views of Strand and Sheeler (Fig. 3). Like Stieglitz's images, they offer the easy order of open foregrounds set against a backdrop of layered buildings (pg. 11). Where Stieglitz's orderly views attend to the layered order of distant buildings, however, in Temkin's views, background buildings are mere backdrops to the foreground gardens. Green has returned to the urban landscape, but not where we might expect it. Looking down from above may no longer be disorienting, but looking down on a shrub-filled rooftop ten stories up is still unnerving (pg. 100).

Gardens, of course, have played the idyll for a very long time, not only in the religious world but the secular realm as well. If their primary role has been to provide food stores, one step beyond subsistence opens the doors to the cultivation of beauty and respite from the imperfections of the day to day. There is a reason that British aesthetic thought valued the pastoral over the beautiful. Perfection of course

is impossible. Allowing either humanity or nature to fully take over has risks, for humanity can bring about its own extinction in its race for perfection, and nature has no need for humans. The pastoral form embraced by the creators of these rooftop gardens accepts that nature will find its own bearings against human activity. Two adjacent gardens planted with the same plants in the same configurations will grow slightly differently even if founded on genetically modified seeds, just as a city grows outward in ways that project order up close, yet miscellany from a distance (pg. 28). And these differences will expand over seasons and years. We find beauty and emotional nourishment in this flow of surprise and difference. Many of the photographs filling this book engage us with the varied splendor of these gardens, and the luxury of their soft greenery against their hard gray surroundings. They offer appealing respites to the boxy vents and compressors that pop up around them. They beckon us with their easy naturalness. But, where the picturesque leaves room for humanity, these rooftop gardens project an unnerving sense of absence. Here, in settings built for and dominated by people, the public is not allowed. Although each garden is unique, and many of them are alluring in their variety of flowers and plant life, they lack the personalized quirkiness of the yards reflected in the photographer's *Private Places* series. But then, green roofs are not meant to be appreciated for their beauty. Nor are they designed to be accessed, like open park space, beckoning us as pathways for escape from asphalt, concrete, and close living. They are botanical responses to a problem.

We have gotten ourselves into a bind with global warming, and Temkin takes this problem to heart, embracing his felt responsibility to point out one active solution. His goal is not to coax us into luxuriating in the gentle beauty of these often flower-laden greenswards as much as to consider the social message that they deliver. Green roofs may cool in summer and provide insulation during the winter. They may absorb air pollution, and dissipate rain water to lessen sewer discharges in times of heavy rain. But they are expensive to implement, and to substantively affect urban climates, 40–50% of roofs would have to go green.[5] Green roofs may be appealing to look at, and Temkin's photographs of them are fine reflections of their allure, but they also are frustrating accusations of our predicament. They stand as cool, unnerving, important records of a time coping piecemeal with an immense problem. They appeal to our love and need of nature, even as they also remind us of our fallibility.

NOTES

1. John D. Magill, Karen Midden, John Groninger, and Matthew Therrell, "A History and Definition of Green Roof Technology with Recommendations for Future Research" (2011) *Research Papers*, Paper 91. Accessed 1/6/15. http://opensiuc.lib.siu.edu/gs_rp/91.

2. According to Amy Norquist, chief executive of Greensulate, one square meter can absorb all the emissions from a car being driven 12,000 miles a year. Accessed 1/6/15 http://opinionator.blogs.nytimes.com/2012/05/23/in-urban-jungles-green-roofs-bring-relief-from-above/?_r=0.

3. Bruce Stutz, "Green Roofs Are Starting to Sprout in American Cities," *Yale Environment 360*, posted December 2, 2010 (accessed 11/28/14 http://e360.yale.edu/feature/green_roofs_are_starting_to_sprout_in_american_cities/2346)

4. Brad Temkin, *Private Places: Photographs of Chicago Gardens* (Chicago: Columbia College Chicago and Center for American Places, 2005).

5. New York City's Department of Design and Construction has estimated that covering half of that city's buildings with green roofs will decrease the city's temperature by 1-4 degrees Fahrenheit. See page 64 in http://www.nyc.gov/html/ddc/downloads/pdf/cool_green_roof_man.pdf .

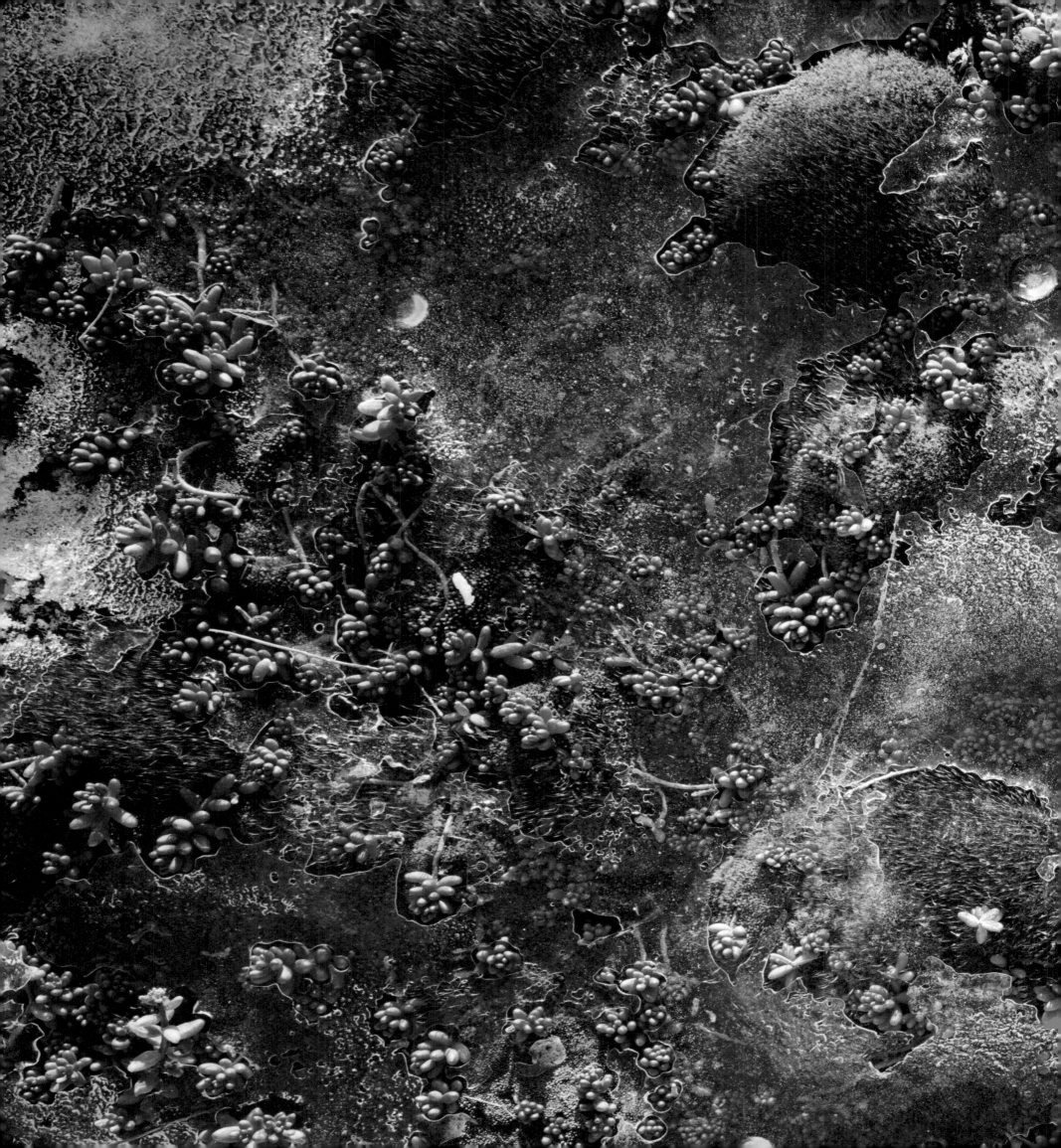

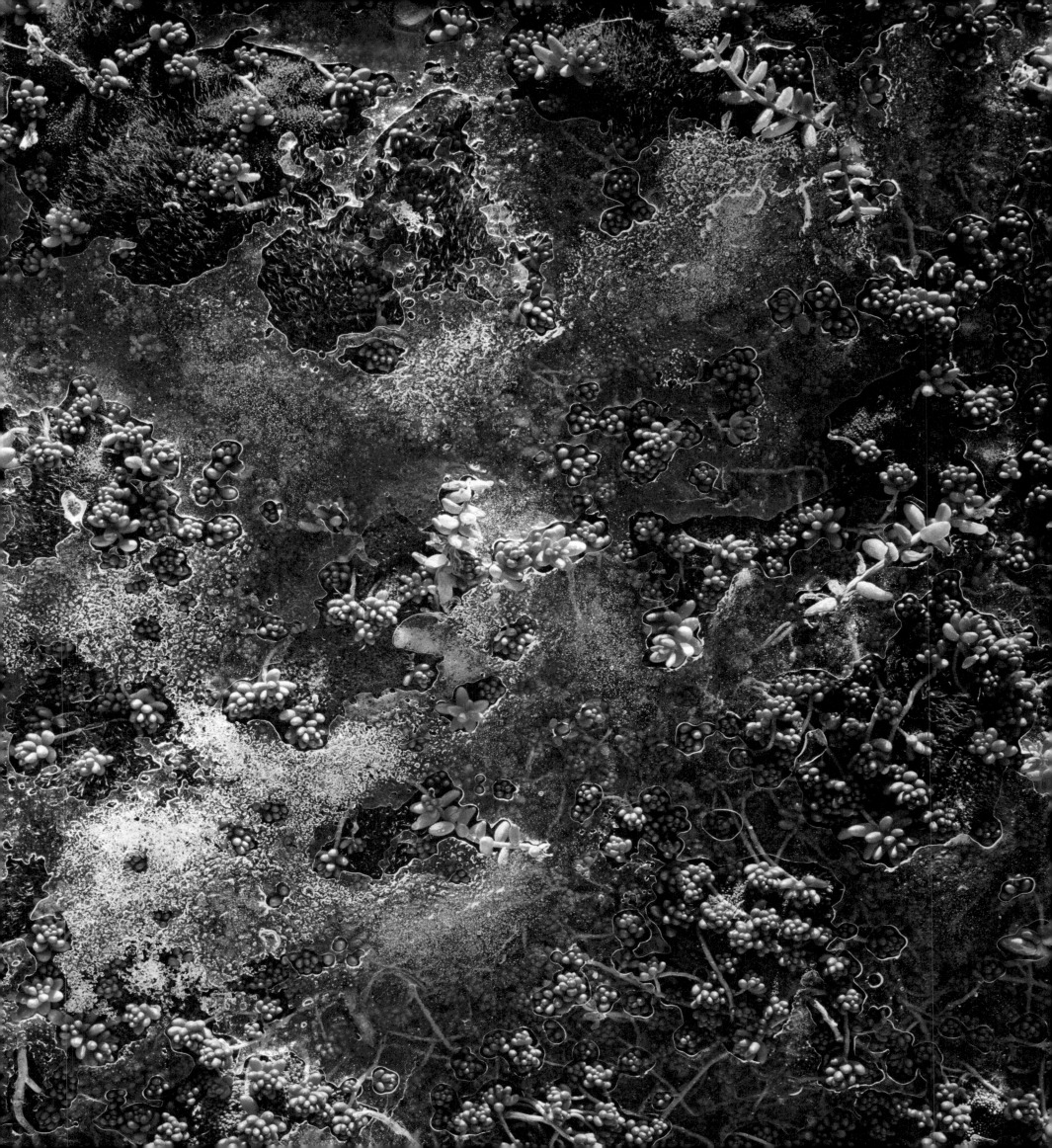

LIST OF PLATES

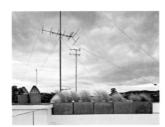

p. iii Birds (looking East), Dún Laoghaire, County Dublin, Ireland, August 2009

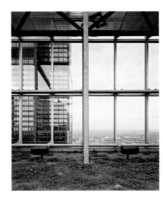

p. v 111 South Wacker Drive (looking South), Chicago, IL, August 2010

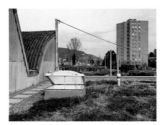

p. vi City Bus Garage (looking East), Basel Switzerland, March 2015

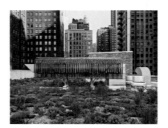

p. ix Randolph Street (looking North), Chicago, IL, April 2010

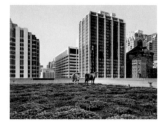

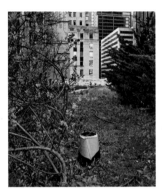

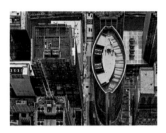

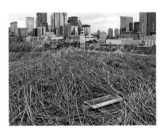

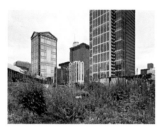

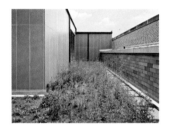

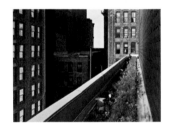

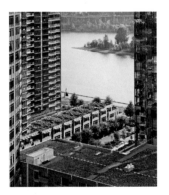

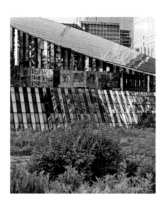

p. 16 City Hall (looking North), Chicago, IL, May 2009

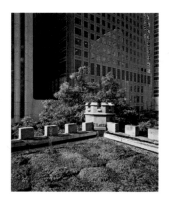

p. 19 Fire House #98 (looking Southwest), Chicago, IL, July 2009

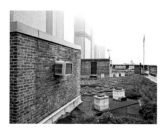

p. 20 Cultural Center (looking East), Chicago, IL, May 2009

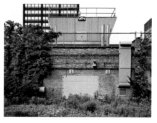

p. 21 City Hall (looking East), Chicago, IL, July 2009

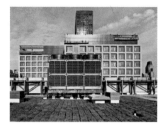

p. 23 Northwestern Memorial Hospital (looking West), Chicago, IL, May 2010

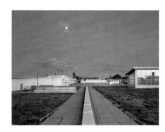

p. 24 The Rouge (looking South), Dearborn, MI, August 2011

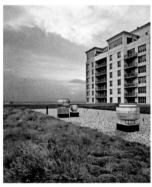

p. 27 USG Headquarters (looking West), Chicago, IL, May 2012

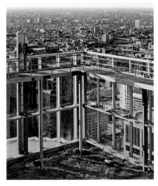

p. 29 111 South Wacker Drive (looking North), Chicago, IL, October 2010

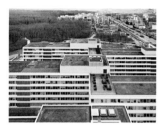

p. 30 EnBW Building (looking East), Stuttgart, Germany, March 2015

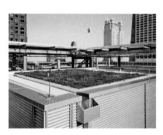

p. 33 Lurie Children's Hospital (looking Northwest), Chicago, IL, May 2012

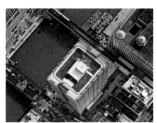

p. 34 Franklin Street (from above, looking Southwest), Chicago, IL, July 2013

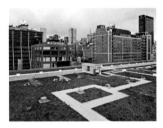

p. 35 US Post Office Sorting Station (looking North), Manhattan, NY, April 2012

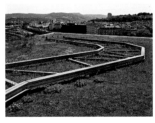

p. 37 Jacob Burckhardt Haus (looking East), Basel, Switzerland, May 2014

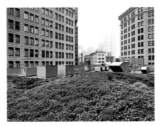

p. 39 Highmark Building (looking West), Pittsburgh, PA, May 2010

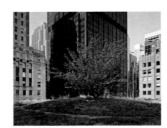

p. 41 City Hall (looking Southwest), Chicago, IL, May 2010

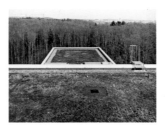

p. 43 EnBW Building (looking North), Stuttgart, Germany, March 2015

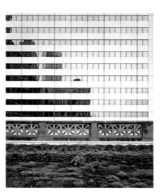

p. 44 Cultural Center (looking North), Chicago, IL, May 2009

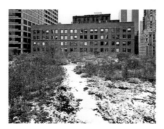

p. 47 City Hall (looking West), Chicago, IL, December 2009

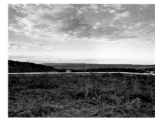

p. 57 Urdorf Süd (looking Northwest), Zurich, Switzerland, May 2014

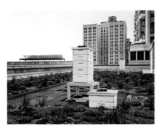

p. 49 Randolph Street (looking Southeast), Chicago, IL, May 2010

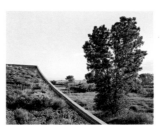

p. 58 Tyner Center (looking Northeast), Glenview, IL, August 2012

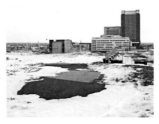

p. 51 Lazarus Building (looking South), Columbus, OH, January 2011

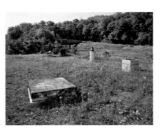

p. 59 Urdof Süd (looking Southeast), Zurich, Switzerland, May 2014

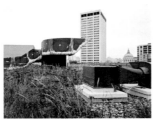

p. 53 1 South Van Ness (looking North), San Francisco, CA, August 2012

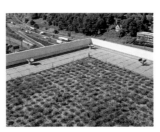

p. 61 Riva Building (looking Southwest), Portland, OR, August 2014

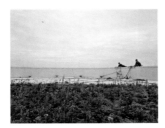

p. 55 Rush University Medical Center (looking Southeast), Chicago, IL, October 2012

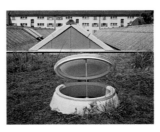

p. 63 BVB Tram Depot (looking West), Basel, Switzerland, May 2014

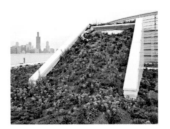

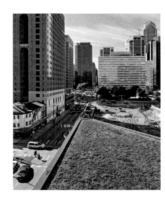

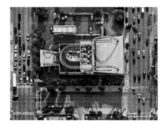

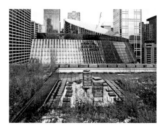

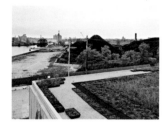

p. 72 Great Lakes WATER Institute, UWM (looking South), Milwaukee, WI, October 2010

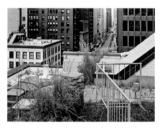

p. 73 10 West Jackson (looking West), Chicago, IL, November 2011

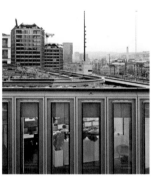

p. 75 UBS Building (looking South), Zurich, Switzerland, March 2015

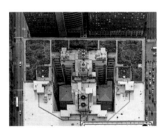

p. 76 City Hall (from above, looking West), Chicago, IL, July 2013

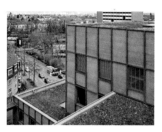

p. 79 Peter Merian Haus (looking Northeast), Basel, Switzerland March 2015

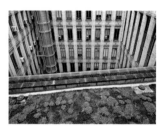

p. 80 Mellon Institute (looking North), Pittsburgh, PA, May 2011

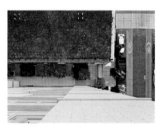

p. 83 ASA Lofts (looking Down), Portland, OR, August 2012

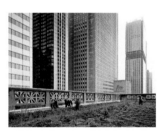

p. 84 Cultural Center (looking East), Chicago, IL, May 2009

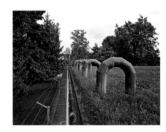

p. 87 Wasserwerk Moos (looking North), Zurich, Switzerland, May 2014

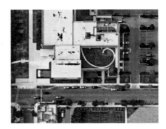

p. 89 Sawyer School (from above, looking North), Chicago, IL, July 2013

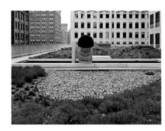

p. 91 Highmark Building (looking North), Pittsburgh, PA, May 2011

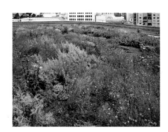

p. 93 1 South Van Ness Street (looking North), San Francisco, CA, August 2012

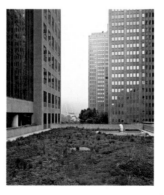

p. 95 Highmark Building with Liberty Bridge (looking South), Pittsburgh, PA, May 2011

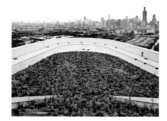

p. 96 Rush University Medical Center (looking Northeast), Chicago, IL, August 2012

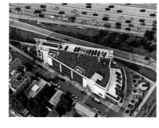

p. 103 North Avenue & I-94 (from above, looking East), Chicago, IL, July 2013

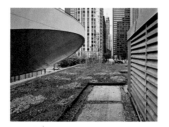

p. 97 Firehouse Engine #13 (looking West), Chicago, IL, November 2011

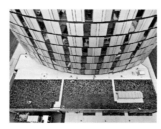

p. 105 Millennium Hall, Drexel University (looking South), Philadelphia, PA, September 2011

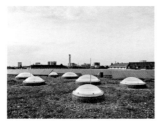

p. 99 Kinderspital (looking North), Basel, Switzerland, May 2014

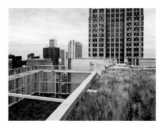

p. 106 111 South Wacker Drive (looking East), Chicago, IL, August 2010

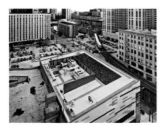

p. 100 Goodman Center (looking Southwest), Chicago, IL, June 2013

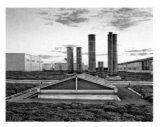

p. 109 The Rouge (looking Southwest), Dearborn, MI, August 2011

BIOGRAPHIES

BRAD TEMKIN

is known for his photographs of contemporary landscape. His work is held in numerous permanent collections, including those of the Art Institute of Chicago; Milwaukee Art Museum; Corcoran Gallery of Art, Washington, DC; Museum of Fine Arts, Houston; Akron Art Museum, Ohio; and Museum of Contemporary Photography, Chicago, among others. His images have appeared in such publications as *Aperture, Black & White Magazine, China Photo, TIME Magazine* and *European Photography*. A monograph of Temkin's work was published in 2005 entitled *Private Places: Photographs of Chicago Gardens* (Center for American Places). He has been an adjunct professor at Columbia College Chicago since 1984.

STEVEN W. PECK

is the founder and president of Green Roofs for Healthy Cities, which was established in 1999. Peck holds an honors BA from McGill University in political science and economics. He spent the past 15 years conducting public policy research in the fields of technology innovation and diffusion, and urban sustainability. In 1999 he co-authored a federal government report on barriers to green roof technology and is the editor and publisher of *Living Architecture Monitor*, a quarterly publication that profiles green roof, living wall developments and research in North America.

ROGER SCHICKEDANTZ

is director at William McDonungh + Partners, since joining in 1994. He has completed projects for Herman Miller, Frito-Lay, and most of the firm's engagements with Ford Motor Company at the historic Ford Rouge Center industrial complex.

JOHN ROHRBACH

is senior curator of photographs at the Amon Carter Museum of American Art in Fort Worth, Texas. Since joining the curatorial staff at the Carter in 1992, Rohrbach has assembled numerous exhibitions on topics of 19th- and 20th-century American photography and written a range of articles and books, including *Eliot Porter: The Color of Wildness* (2001), *Accommodating Nature: The Photographs of Frank Gohlke* (2007), and *Color: American Photography Transformed* (2013). He also is co-editor with Gregory Foster-Rice of the book *Reframing the New Topographics* (2011). Prior to coming to Fort Worth, Rohrbach worked at George Eastman House and was director of the Paul Strand Archive.

ACKNOWLEDGMENTS

POSITIVE AND PROFOUND CHANGE comes about when groups of people work together to implement their vision. I am fortunate to have had the support and generosity of so many people while making these pictures.

My family, who truly accept and understand my eccentric needs. Joyce, you are my compass and always tell me the truth whether I like it or not. Mia, who keeps me smiling (mostly) and humble. And my father, who continues to inspire the kind of man I am.

I am lucky to know Pat and Susan Frangella, two people who have always thought beyond themselves, and throughout the years have provided strong friendship and support of my work, and in particular this project. Special thanks to Kevin Miller & Juliana Romnes, and the Southeast Museum of Photography for supporting this publication and curating the traveling exhibition. Generous support was also provided by my friend Ed Osowski, Columbia College Chicago, and Innova Art Ltd.

Thank you to John Rohrbach for his friendship and honest feedback about my work. To Steven Peck for his vision and introductions. To Roger Schickedantz for sharing his interest of design and sustainability.

Making these pictures was most important, but in making the book, the pictures and the message are realized. David Chickey and David Skolkin's understanding for this project and my intent led to a dynamic design that was true collaboration.

I'd like to offer sincerest thanks to the following individuals, institutions, and corporations for their support, advice, access, and advocacy: Greg Knight, Nathan Mason, the City of Chicago, Wendy Watriss, Fred Baldwin, Steven Evans, Roger Gaudette, Ford Motor Company, Tom Liptan, Michael Berkshire, Joan Morgenstern, Becky Senf, Kate Ware, Anne Tucker, Paul Berlanga, Dave Williams, Scott Nichols, John Chakeres, Howard Bossen, Marilyn Castro, Ira Schwartz, Laurie Lambrecht, Luis Delgado, Magda Mioduszewska, Green Roofs for Healthy Cities, Marta Sánchez Philippe, Irina Chmyreva, Evgeny Berezner, Elda Harrington, Silvia Mangialardi, Natasha Egan, Karen Irvine, Jamie Allen, Lisa Hostetler, Jennifer Ward, FotoFest, Gunter Mann, David Travis, Howard Lerner, Jill Geiger, Terry Evans, Cooper Scanlon, Keith Johnson, Darla Cravotta, Susan Burnstine, Ferit Kuyas, Frazier King, Aron Gent, and Rania Matar.

These pictures celebrate and proliferate new ideas in design, showing the inventiveness in architecture and accommodating our need for nature. In spite of our folly, we find grace. I am an optimist!

FRONT COVER: Highmark Building (looking Down),
Pittsburgh, PA, May 2011

BACK COVER: University Hospital (looking Down),
Basel, Switzerland, May 2014

p. 2: Best Buy (looking Down), Chicago, IL,
October 2010

p. 4: Highmark Building (looking Down),
Pittsburgh, May 2011

pp. 8–9: Federal Reserve Bank (looking Down),
Houston, TX, March 2013

pp. 16–17: Kinderspital (looking Down),
Basel, Switzerland, March 2015

pp. 22–23: The Rouge (looking Down),
Dearborn, MI, February 2012

RADIUS BOOKS

227 E. Palace Ave. Suite W
Santa Fe, NM 87501
t: (505) 983–4068
www.radiusbooks.org

Available through

D.A.P. / DISTRIBUTED ART PUBLISHERS
155 Sixth Ave., 2nd Floor
New York, NY 10013
t: (212) 627–1999
www.artbook.com

ISBN 978–1–934435–94–6

Library of Congress Cataloging-in-Publication Data
available from the publisher upon request.

DESIGN: David Chickey, David Skolkin
COPY EDITING & PROOFING: Laura Addison
PRE-PRESS: John Vokoun

Printed by Editoriale Bortolazzi-Stei, Verona, Italy